Eugène Atget, a merchant seaman-turned-actor, changed direction to become a photographer in around 1888 after realizing ' that his largely mediocre stage career was petering out. Over the next thirty-10,000 large-plate negatives of the art, arch and its environs. His ambitions for his new c that his images were merely 'documents for ar

cary records to interested individuals and public institutions, where they were filed under their respective subjects rather than their author's name, which was deemed to be unimportant. During his lifetime, he was regarded only as a reliable, if eccentric professional; a contributor to the great catalogue of French culture which was being compiled by the Parisian libraries and archives. Even in France today, he is seen by some merely as an exemplar – not necessarily the greatest – of a tradition in French architectural photography which began in the 1850s. It was then that the Commission des Monuments Historiques assigned such notable photographers as Henri Le Secq, Gustave e Gray and Edouard Baldus to document the architecture and landscape of France in the Missions Héliographiques and similar ventures.

Yet there is another view of Atget. The plaque set up to honour him outside his old residence in the rue Campagne-Première, Montparnasse, refers to him as the 'father of modern photography'. And John Szarkowski, curator emeritus of photography at the Museum of Modern Art in New York, where half of Atget's studio archive now resides, is quite unequivocal. Atget, he declares, was perhaps the best example of what a photographer might be'. In the period since his death in 1927, Atget's reputation has soared from that of a modest journeyman, known mainly to the confined circle of his customers, to a photographic *naïf* who 'got lucky' every dozen pictures or so, to that of the twentieth

century's pre-eminent photographic artist. This unprecedented elevation is seen, in certain quarters – especially postmodern theorists concerned with contextualization – as wilfully misconceived, the fraudulent conversion of a purely functional commercial hack to the status of major photographic artist. Inevitably, such divergent views have been the cause of an 'Atget problem'. The loaded term 'artist' is at the heart of the dilemma. In having the perspicacity to leave no manifesto, except for two or three enigmatic sentences, Atget ensured a field day for posthumous interpretation. Theorists, art historians and critics have a convenient blank canvas upon which they can construct (or deconstruct) the correct ideological profile. For contextualists, Atget's artistic canonization is considered perhaps the most flagrant example of a process whereby the colonizing agencies of modernism – the art museum and traditional art historical analysis – appropriate the work of strictly utilitarian photographers for aesthetic discourse. This process, with its assumption of notions concerning *auteur*, style and oeuvre, is criticized not just on grounds of arrogance and intellectual logic, but more radically, for its iniquitous drawing of further bankable assets into the orbit of the art market.

There are complicated issues involving modernist and postmodernist ideologies involved here, but two points about Atget seem self-evident. Firstly, he has been an enormous influence upon twentieth-century photography – upon the way photographers think about photography and how they take pictures. That cannot be denied. Secondly, there is the fundamental paradox that, despite his reputation and influence, his work remains too muted for many tastes. Numerous photographers have expressed a certain disappointment in Atget. If an essential criterion for the artist-photographer is a degree of intentional mediation between the mundane record and the creative image, too often this

Gerry Badger

EUGENE ATGET 55

Φ

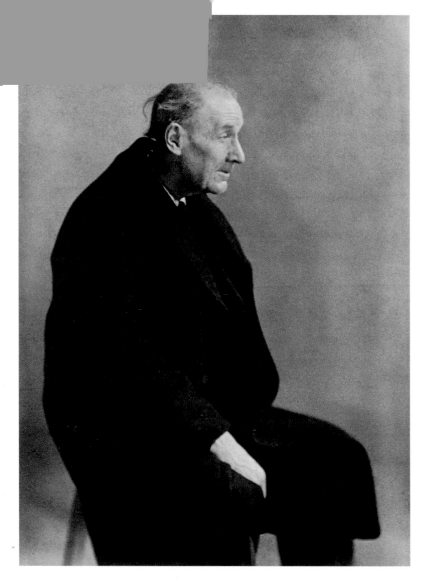

seems to be lacking. Judged by the purely formalist standards of photographic modernism, his pictures are often found wanting.

The problem for modernists is that Atget's work does not resolve itself neatly into the conventional model for artistic production. He produced a body of work to satisfy the standards of simple clarity demanded by a primarily institutional clientele. By aesthetic standards, much of it was formally uneven. Accepted categories for an artist-photographer's career – considerations of formal success vis-à-vis formal failure, stylistic development, the issue of commissioned as opposed to personal work – would not be readily applicable to Atget. So, if we consider his work as art rather than commerce, are we distorting history, and at what cost? Perhaps the cost is one demanded by the pictures themselves. For, just as the dilemma of his commercial practice remains for the aesthetes, so one indelible problem remains to confound the contextualists. The critic Max Kozloff has written, 'The viewer of these images falls prey to a loveliness unbounded by any consideration of trade. Going through this archive more carefully, one can be enveloped in reserves of poignance, for which the extensively modest function of the imagery and the mechanistic aspects of its coverage do not prepare. In this accumulative experience, a sense is gradually built up that the explicit, mundane programme of the work has been infused into an infinitely larger and more private vision that nowhere acknowledges itself. The problem of Atget is how to talk about that.' If we begin to talk about the issues this problem raises, we will address some of the problems raised by the medium, for the 'Atget problem' is essentially the problem of photography. What exactly is the art of documentary photography? Atget has much to tell us about that, but first we must examine his commercial practice more closely.

In 1920, when Atget offered some 2,600 of his negatives to the Service Photographique des Monuments Historiques, he wrote the following, a precise summation of his career and the clearest statement of his intentions that we have: 'Sir, for more than twenty years I have been working alone and on my own initiative in all the old streets of Paris, to make a collection of 18 x 24 cm negatives: artistic documents of beautiful urban architecture from the 16th to the 19th centuries ... Today this enormous artistic and documentary collection is finished: I can safely say that I possess all of Old Paris.' Originally intended to furnish visual references to the artistic community – painters, designers, craftsmen, architects – the enterprise begun by Atget back in 1888 had developed by the 1920s into a huge compendium of Parisian buildings, townscape views and decorative architectural details. At first, he had struggled in his new business, but it blossomed after his decision (in around 1897) to photograph 'Old Paris'. That decision broadened his client base from individuals to institutions. If, as we will see, Atget baulked at working directly for the state, he was not averse to servicing the state.

Vieux Paris was not simply a pictorial genre, it was an attitude, an ideology. Throughout the nineteenth century, as the industrial revolution wrought irrevocable changes in France, there was a politicized, bureaucratically sanctioned concern by the state for the heritage of '*Le Patrimoine*', expressed in the need – even before photography – to make systematic pictorial inventories of the French past. There was a particular concern to record areas under threat from those following the lead of Baron Haussmann and seeking to demolish old city districts wholesale in order to construct the brave new bourgeois world. Paradoxically, the ruthless imperative of the property developer and bureaucratic town planner was frequently accompanied by a

sentimental regard for that which they were destroying. The impulse to archive the French cultural heritage was especially strong at the end of the nineteenth century, with the *Vieux Paris* movement and the commission set up to mitigate the effect the building of the Paris métro would have on those historic areas which had survived Haussmann's radical redevelopment of the 1860s. Institutions, such as the Bibliothèque Historique de la Ville de Paris, the Musée Carnavalet and the Bibliothèque Nationale vied with each other in acquiring drawings, prints, photographs and other documents relating to the Parisian past. Photographers were either commissioned or, like Atget, produced work on spec'. This was Atget's primary market. He was making photographs not to create an oeuvre – the presumed goal of an artist – but to furnish an archive. Atget organized his work into long series, some of them lasting throughout his career. There were five major groups: Landscapes-Documents; Old Paris; Art in Old Paris; Environs of Paris; and Topography of Old Paris, each with sub-series related to the major. Again, though it might be tempting to analyse these groupings for signs of an artistic masterplan, they would seem to be more of an administrative and commercial convenience. Atget was required to adhere to a strict discipline, the primary constraints of which were to work systematically in series and to describe things with lucidity. The heavy view camera and its large glass-plate negatives – which gave rise to the legend of Atget, the photographic *naïf* trudging the streets burdened by unnecessarily cumbersome equipment – was simply a mandatory requirement. Architectural photography necessitated a camera capable of resolving great detail, of correcting verticals by means of camera movements; this technique was inevitably slow and deliberate, and certainly unsuited to the kind of street photography which sought to catch life on the wing. Occasionally he attempted candid street photography, but without conspicuous success. His one major effort to photograph a series

of statically posed portraits of street trades-people – the 'Petits Métiers' – was a direct transcription into photography of a long-established pictorial genre, and was quite a commercial success for him. But Atget, to use a stage analogy, was interested in the *mise-en-scène* rather than the actors. His main business was as a purveyor of architecture and topographical townscape views, which he sold by the dozen to individual customers and by the hundred to the institutions. So far, there is little to distinguish him from other photographers who catered for the *Vieux Paris* market.

Surely there must be reasons for the quantum leap from honest journeyman to great photographer, other than some formally striking pictures among a good many dull ones? The answer lies, for those interested in both aesthetics and social history, in how and where Atget contravenes the conventional discourse of architectural photography, an essentially conservative genre. *Vieux Paris* represented a somewhat sentimental, sanitized, bourgeois notion of history. Atget – a lifelong socialist and eccentric dissident – while nominally fulfilling his brief, seems to have wilfully interrupted, contradicted and subverted this bourgeois history. In 1931 the young Walker Evans, one of the earliest and canniest of commentators on Atget, furnished us with a vital clue, not so much about Atget's vision of his work, which we can only guess at, but rather about the idea of Atget himself: 'His general note is lyrical understanding of the street, trained observation of it, special feeling for patina, eye for revealing detail, over all of which is thrown a poetry which is not "the poetry of the street" or "the poetry of Paris" but the projection of Atget's person.' In short there is something – albeit highly elusive – that we can term 'Atget's Paris'. It is laid over, or appears to slip in and out of the official Paris he was supposed to be objectively documenting, in and out in different ways, none of which in

themselves are particularly unusual, but which collectively add up to a photographer who, at the very least, was highly eccentric. As the art historian Molly Nesbitt has written, he photographed deliberately with his own 'inflected, rebellious, melancholy and moral sense of history'.

Atget's emphasis, both formally and in terms of content, tended to differ in significant ways from those photographers who were more accepting of the need to reflect absolutely their institutional employers' expectations. Atget's camera, for instance, with its extreme wide-angle lens, was an adequate but not ideal tool. It required care in use or it could distort objects. Yet Atget's deployment of it was frequently careless. He did not always correct verticals, he did not seem to care about lens flare, or the ability of the lens to cover the negative. And if photographing a facade, he frequently allowed distracting elements, such as extraneous street furniture or curious urchins, into the frame as if positively encouraging commonplace street life to disturb the classical calm of historic Paris, at the risk of irritating his institutional customers.

Atget's use (or misuse) of this extreme lens – which, tellingly, he utilized for most of his career – makes for work that, at its best, is engagingly nervy and immediate. He seems to have accepted, even encouraged the tendency of the lens to create a dynamic spatial character, thereby rejecting the flatter, more measured perspective demanded by more conventional architectural representation. Much in Atget's work seems slightly off-kilter, slapdash or casual, so when his images do not work in a formal sense, they are – dare one say it – a little crass, compared even to his less exalted rivals. When they do work, no one has photographed better. In the best of Atget's imagery, visual faults become supreme virtues. The sense of space in a picture becomes

expanded rather than flattened, and the result is an altogether more dynamic, livelier and more immediate record than those of his 'correct' contemporaries. However, although we might wonder at how well Atget put together his images on occasion, every would-be photographic artist should heed Max Kozloff's wise words. He rightly notes that 'If an Atget image were endowed with all the [formal] grace in the world, but bereft of Atget's time-honoured sense of the world, we would not recognize or care that the image is his. It would be truly soft in content, regardless of how well masses are arranged within the frame.' We are still seeking, therefore, that 'projection of Atget's person', the point where his private vision begins to assert itself – Atget's 'real' subject.

One word crops up frequently with regard to Atget – history. It is used by commentators with widely differing views to draw widely differing conclusions. On the surface, it seems obvious. Atget's official business was, after all, history, and he could be said to have photographed in a continuous dialogue with history. But there are different kinds of history and different kinds of dialogue with history to be made with photographs. A family snapshot is about personal history. A standard photographic document is about official history. Or, given a different inflection, about histories contrary to the official version. Atget's relationship with history, as with his graphic disposition of forms within the frame, was not consistent. Therein lies the dilemma of Atget. His working methods were fragmentary, contingent and idiosyncratic, if judged by the standards of his fellow documentarians of *Vieux Paris*. Different histories entered and quit the fringes of the main enterprise, and he deviated from the norm in often quirky and apparently inconsequential ways, never leaving a thread that could be traced with confidence, never allowing a substantial profile of his intentions to be built up by the determinist critic. One cannot be

too dogmatic about Atget. For instance, one recently popular view of him, the antithesis of the modernist, is as the socio-politicist furtively harbouring a dissident political consciousness which underscores his work, surfacing whenever the opportunity presents itself. In his photographs of the poorer quarters of Paris, or in images dealing with the contemporaneous rather than the nostalgic, we see some of the social deprivation engendered by the industrialization of Paris, and might glimpse a politically aware, conscious *auteur* of a very different tenor from that envisaged by the aesthetic lobby. Yet it is only a shadowy glimpse. Surely, if meaningful, readily understood political analysis was central to his intention, he would have tended to focus rather more programmatically upon evidences of the city's iniquities. The picture remains maddeningly incomplete, and the view of Atget the political photographer is ultimately as unconvincing as Atget the photographic aesthete. Nevertheless, it is an important strand in Atget's make-up and should be given due credence. It seems as necessary to rescue Atget from the vacuity of formalist modernism as it is to claim him for creative photography.

Aesthetically wonderful, the late elegiac landscapes from Saint-Cloud and Sceaux should not be divorced from the rest of his production and trumpeted as proof of his formal genius, without considering, in equal measure, other more prosaic or inconveniently political aspects of his pictorial personality. Beyond the dictates of commerce, varying impulses seemed to have gained sway over Atget at various times. Why photograph tree roots, for example? Why the apparent obsession with autumnal spectres? Is it too absurd to grant Atget internal motives for pointing the camera, even the simple joy of looking? Is it too absurd to credit Atget with some aesthetic awareness, even aesthetic ambition in a modest sense? He was, after all, a widely read, if a self-educated

man. Is it equally absurd not to recognize his political voice in the work, how-ever subtly realized? If the work is a projection of his personality, his different interests must be contained within it. We do not perpetrate some transgression of an immutable, higher moral order (except possibly that of art theorists) if we recognize widely differing Atgets – public, private, mundane, inspired, formalist, political and so on. And if we are left with an oeuvre upon which it is difficult to impose a wholly rational context or formal pattern – too bad. Many things might move a photographer, but not always to take a photograph.

But still we are left up in the air, grasping tantalizingly at the substance of Atget's grand design. Perhaps his own words might offer a slender clue. 'I can safely say that I possess all of Old Paris,' he wrote. Possess – an interesting word in relation to photography. In writing about the American photographer Garry Winogrand, Leo Rubinfein noted that the work constantly suggests Winogrand's 'estrangement from the world and the photographer's imaginative reclaiming of it'. Reclamation – another telling word. Look at Atget and the way he constantly stresses the city seen from an 'ordinary' point of view. Look how one enters and flows round an Atget image, compelled by its kinaesthetic and tactile qualities. We are invited to possess or reclaim the picture space in a way offered by few other photographers. Consider also the areas of Parisian experience reclaimed by Atget. All of Old Paris? Not at all. Atget's Paris was pedestrian, working class, a largely pre-industrial, small-scale, disregarded Paris of narrow streets and hidden courts. If not quite a Paris of the 'other', at least a Paris of the ordinary. Bourgeois Paris, of the *grands boulevards*, or Bourbon Paris was antithetical to Atget's true domain, creeping into his grand design only as far as was necessary to furnish his living.

This act of imaginative possession seems twofold – at once purely personal, seeking 'time regained' in a Proustian sense, and also personal-political, seeking to reclaim French culture for his class, inculcating another, subtly dissident voice into the official archive. This is where we might begin to locate something of the unnerving fascination in Atget. We can observe a flitting between impersonal and personal enquiry, between history and his story. We can mark a profound shift from a record of observation to a record of experience. And note how, through this gradual, often barely perceptible change in emphasis, the work acquires 'an existential tenor', as curator Maria Morris Hambourg put it. Thus Atget's larger theme becomes not simply the cataloguing of French culture, not even a divining of its spirit (as many commentators have concluded), but a chronicling of the experience of that culture, as set down by a peculiarly receptive, feeling eye. And as revealed by a medium eminently capable of setting down a myriad of contingent sense impressions, suited, in the words of John Szarkowski, to exploring 'freely, without formulation, the kaleidoscopic truths of meaningful aspect'. From this stems all the animism, melancholy and loveliness to be discerned in Atget. We are put directly in contact with a life, a singular personality, with a relevant story to tell. Here is Atget's true value, his legacy to all those practitioners who have been inspired to produce photographic works displaying a like-minded spirit of poetic response to historical fact.

Atget's ultimate importance lies not so much in formal innovation – though he offers an endlessly rich lesson in how to structure a photograph – but in the fact that his work tends to remove photography from the formalist clutches of modernism, demanding for it a clear narrative imperative (no matter how oblique or fractured that imperative in practice), thus locating the medium

firmly in the world. The clear 'projection of Atget's personality' reminds us that the photograph is clearly an *auteur*'s construct; in essence a fiction, but a fiction rooted in and tied to actuality, time and history – in a complex, often highly problematic way. To recognize the medium's fictional qualities is not to say that Atget, or any other photographer, deploys their subject matter as the raw material from which to invent a purely private world. Rather, it is to suggest that the record of personal existence is made to tell some of the larger, more impersonal truths of our culture. The photographer Robert Adams, surely one of Atget's natural heirs, has written the following: '[Photography] can offer us, I think, three verities – geography, autobiography and metaphor. Geography is, if taken alone, sometimes boring, autobiography is frequently trivial, and metaphor can be dubious. But taken together … the three kinds of representation strengthen each other and reinforce what we all work to keep intact – an affection for life.' I think Adams might have added a fourth verity – history; for history permeates his own work as it does Atget's, making them both benchmark photographers. It is that crucial addition which justifies Eugène Atget's honoured place in the art of photography, lending his work its moral rectitude and profound seriousness, qualities rare in a medium where superficiality seems the constant temptation. It is history permeated with autobiography that makes Atget so peculiarly compelling.

Molly Nesbitt has posed a tricky question. What, she has asked, can we actually do with the work of Atget? What is the knowledge that Atget gives us? Of what, to paraphrase Walter Benjamin, are Atget's images standard evidence? If written down in a few bald words, or stored, as until relatively recently, in dozens of neglected, dusty boxes, perhaps not very much. A catalogue of *fin de siècle* French culture? A compendium of Gothic and Baroque, of Neo-Classical,

Art Nouveau and Vernacular? A subtle indictment of the ravages of nineteenth-century capitalism? A nostalgic reverie for proto-industrial, pastoral France? Can these photographs really add much to the knowledge we have of these things from many other quarters? Can they seriously match the knowledge we have received from the great artists who have made the epicentre of European culture their primary obsession? Atget did not have at his ready command the colour and limitless formal armoury of Degas or Manet. He could not hope to deal, like Zola or Proust, with the abstractions of history or complex psychological nuance. Yet Atget, like a master magician, could conjure from his simple black box the trace of actuality. He could reveal the physiognomy of history, transcribe meaningful, visible facts that the written text or painted image could merely approximate. In Atget, we see the very stuff of an individual existence in a particular place and at a particular time, permeated with his intuitive, but complex and deeply intelligent sense of the world. Photography for Atget may have begun as a substantially interesting way of making a living. It became the place where he demonstrated and shared with posterity his own indomitable affection for life. Photography gave him the means to create a profound and affecting meditation upon existence.

Many have had their say, but the best judgement on Atget surely remains that of John Szarkowski, written in 1969: 'What Eugène Atget was, without doubt, was a photographer: part hunter, part historian, part artisan, magpie, teacher, taxonomist and poet. The body of work he produced in his thirty working years provides perhaps the best example of what a photographer might be.'

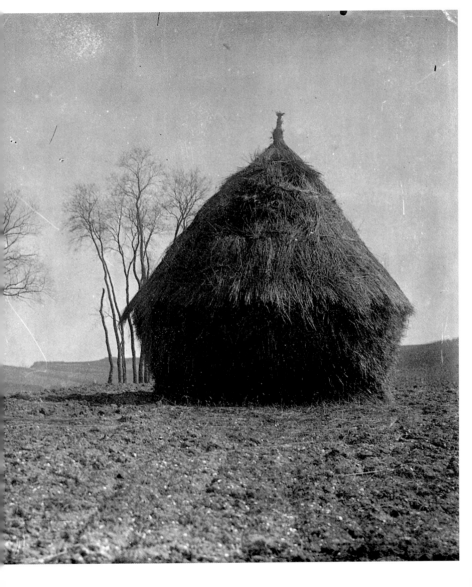

(previous page) **Abbeville, Somme, before 1900.** Atget is known to be a photographer of Paris and its environs. However, he began his photographic career in Picardy, and photographed the countryside with as much avidity as the city. He probably made this technically inept but visually masterly image of a haystack between 1888 and 1892, when he was still learning the game of photography, and did not return to this classic subject for almost forty years. In each case the stack is depicted not as a flimsy mirage dissolved by light, as in Monet, but as a brooding massive sculpture, rooted firmly in the earth and the endless cycle of rural life.

Café, Champs-Elysées, Paris, 1898. Atget's early career was spent in providing motifs for artists, so it is no surprise to find him making candid, almost impressionistic pictures of people on the streets, such as this view of a crowded café on the Champs-Elysées, a site not usually associated with him. The use of his cumbersome view camera (with attendant tripod and black cloth) for such 'slices of life' did not always ensure technical or aesthetic success, and this clearly unsuitable mode soon transmogrified into the 'Petits Métiers' (small trades), a series of portraits depicting a theme long popular in European art iconography, also known as 'Cris de Paris' (Street Cries of Paris).

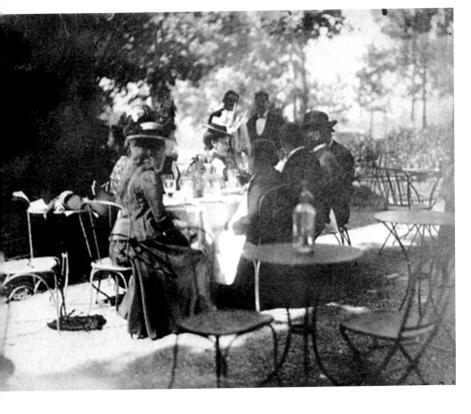

Organ-grinder, Paris, 1898. The more considered, posed street portraits of the 'Petits Métiers' series generally solved the problems engendered by making street candids with a tripod-based camera. This well-worn theme actually brought Atget a deal of commercial success, and some eighty of them were published in postcard form. Generally, their abiding characteristic is insouciant objectivity. Atget's subjects just stand there, without expression or concern. This does not make them lumpen or charmless, just vividly there. The *Organ-grinder*, however, is rather different. The grizzled organist is suitably matter of fact, but as John Fraser, author of an important essay on Atget, remarked, 'the expression of radiant, exultant happiness and pride on the woman's face is unequalled by anything I can recall in art'.

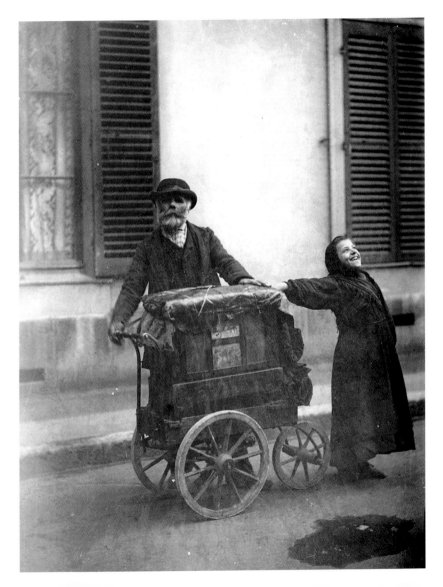

Untitled (The Lampshade Seller), Paris, 1899. In this noteworthy example of the 'Petits Métiers', one of Atget's best-known images, note the supreme, almost comical matter-of-factness of the pose and the photographer's disinterested approach. Atget was concerned primarily with photographing types, not individuals, though the sometimes bizarre details of equipment, accoutrement and method can be character enough. Generally, Atget seems to have used a longer focus lens than usual for this series, but here he employed the extreme wide angle so associated with his work, producing the deep space and steep perspective typical of much of his oeuvre. It emphasizes the paving stones, a recurring feature, marking his vision as a particular depiction of the urban walking experience.

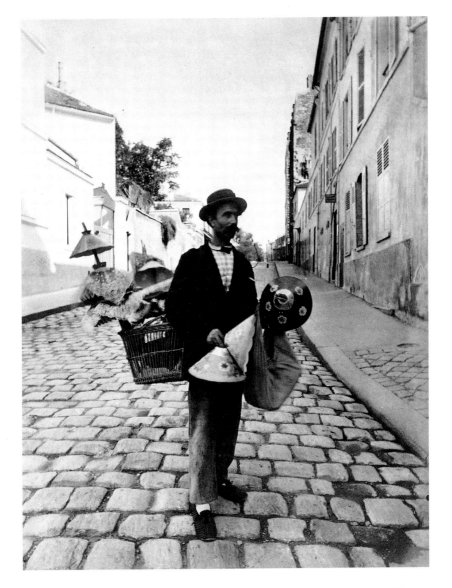

At the Dragon, Entrance to the Courtyard, 50 rue de Rennes, Paris, 1899. The defining moment in Atget's career was his decision, made around 1897, to photograph 'Old Paris'. By the end of his life, he had made over 3,000 pictures on this theme, encompassing views of individual buildings, their decoration and topographical townscape views. In catering to this market, he made many serviceable and relatively dull records of architecture and ornamental details, but it is where he became less 'correct' and flaunts the picturesque mode – not bothering to move an intrusive tricycle, for example – that he surpasses his strictly conventional contemporaries. As Maria Morris Hambourg has written, Atget's special talent was to fix 'his frame to focus attention upon the motif without removing it from the context of lived experience'.

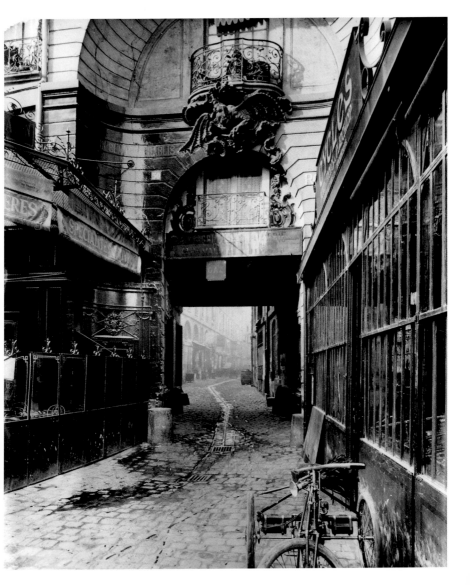

Pavers, Paris, 1899–1900. In this lesser known example of the 'Petits Métiers' depicting the laying of those ubiquitous paving stones, Atget has combined posed and candid modes with conspicuous success, employing a shallower depth-of-field (therefore faster shutter speed) than usual in order to arrest motion somewhat. This effect was probably exaggerated by using a longer focal length lens than usual. If one remembers that the camera was tripod-mounted, therefore completely stationary, and that he could not look through the ground glass screen of his view camera at the moment of taking, his success in gathering together the picture's disparate elements into a cohesive pattern from the continuous flux of movement in front of him becomes the more remarkable.

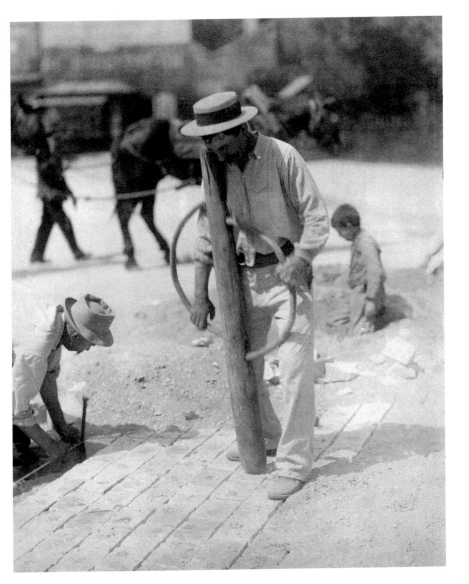

Rue Saint-Jacques, At the Corner of the rue Saint-Séverin, Paris, 1899. An important part of Atget's practice was to make systematic records – street by street, almost building by building – of *quartiers* under threat of modernization. He photographed the area around the churches of Saint Séverin and Saint Julien le Pauvre on the Left Bank for much of his career, returning as buildings were being demolished and the old medieval character irrevocably changed. Only a year or so after this lively, evocative image was made – one of his most animated – these buildings at the east end of the church were torn down to permit the widening of the rue Saint-Jacques, which was extremely narrow at this point, thus exposing the apse to the busy thoroughfare.

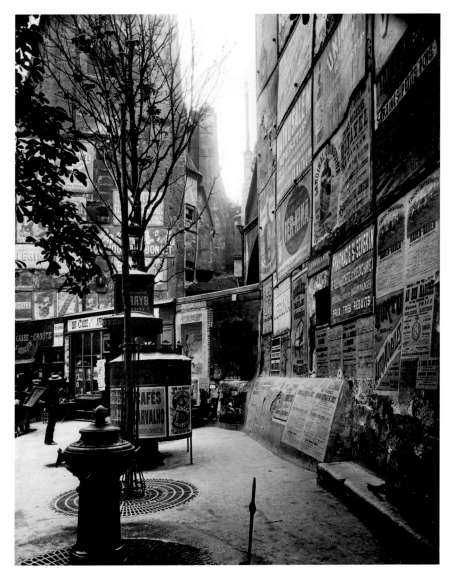

Rue des Ursins, Paris, 1900. The rue des Ursins is near Notre-Dame on the Île de la Cité, part of a small neighbourhood of medieval streets which has escaped wholesale demolition. Atget photographed this street in 1900, and then again more than two decades later, and little had changed. Even today, the scene remains essentially the same, though predictably it has been greatly gentrified since Atget documented it. This, the earlier view, is almost a summation of Atget's Paris. A park, certainly, is missing, but almost everything else is here: the pissoir, the old vehicle, the shop signs, the street lettering, the weathered facades and, above all, the paving stones which draw us easily into the picture space and the world within.

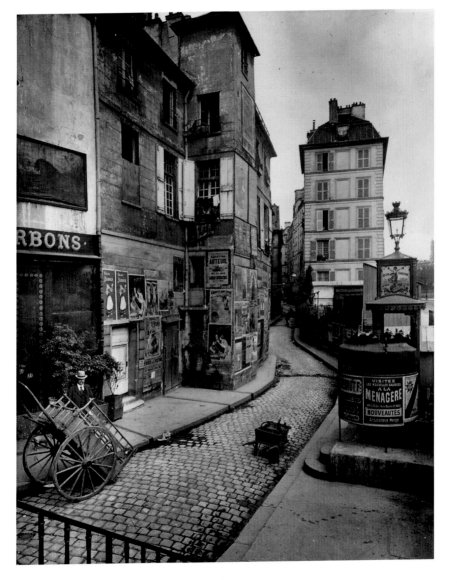

The Bièvre, Gentilly, Paris, 1901. If, as his friend André Calmettes stated, Atget's aim was 'to photograph all that was artistic and picturesque in Paris', this does not imply total licence in choice of subject; though, as always, he remained his own man. The picturesque was a precise genre to the 'Old Paris' *aficionado*, focusing on urban decay in a particularly sentimental way – 'part of the procedure for not seeing poverty', according to Molly Nesbitt. Atget, it would seem, borrowed the genre but not its usual cheap rhetoric. His gracefully composed, but sober view of industrial blight along the River Bièvre, in the southern part of Paris, would indicate that his interest in history and patina was complex, troubled and determinedly unsentimental.

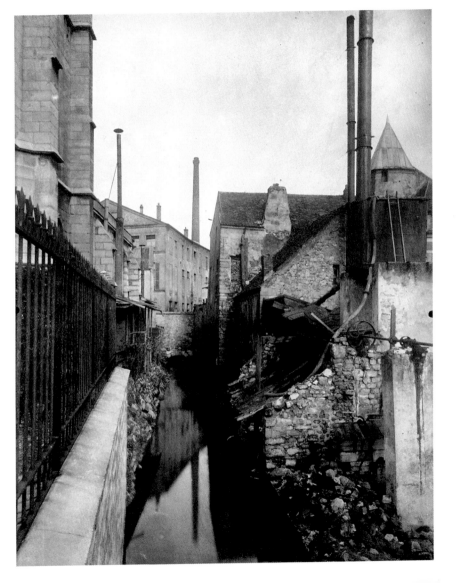

À L'Homme Armé, 25 rue des Blancs Manteaux, Paris, 1900. Like the documen tation of itinerant street trades, the recording of commercial signs and stre furniture was typical of the enterprise to record 'Old Paris'. Because the served alcohol and were open after dark, the bistros, cabarets and inns of Par were required to be protected with ironwork grilles, often highly decorate Atget made the most of his early pictures of such ironwork, signs an shopfronts between 1900 and 1908, when he added 'Art in Old Paris' to his 'O Paris' series. Then, in 1913, he bound them into a book entitled *Enseignes vieilles boutiques du vieux Paris*, one of seven albums on specific themes he so to the Bibliothèque Nationale that year, firmly establishing himself as an 'autho and editor'.

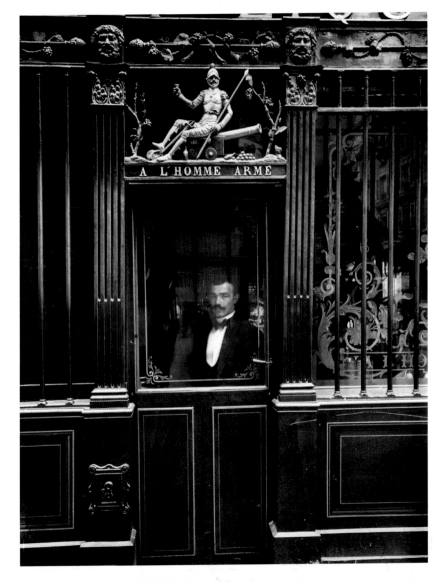

Rue Charlot, 83, Hôtel du Marquis de Mascarini, Paris, 1901. An important par
of Atget's commercial practice in the first decade of the twentieth century wa
to systematically photograph the *hôtels particuliers*, the large private town
houses of the Marais, Temple, Saint-Germain and other unmodernized districts
focusing upon the architecture, the buildings' elevations and massing, and upo
decorative details. Much of this work was routine. Indeed, it was required to b
so, merely obeying the dictates of lucid, disinterested description. Atget took
great many dull architectural pictures in this vein, his apparent dislike of rou
tine sometimes resulting in carelessness and ineptness. But in this typical, i
superior example, his tendency to photograph from a slight angle rather tha
head-on enlivens a somewhat prosaic, if elegant subject.

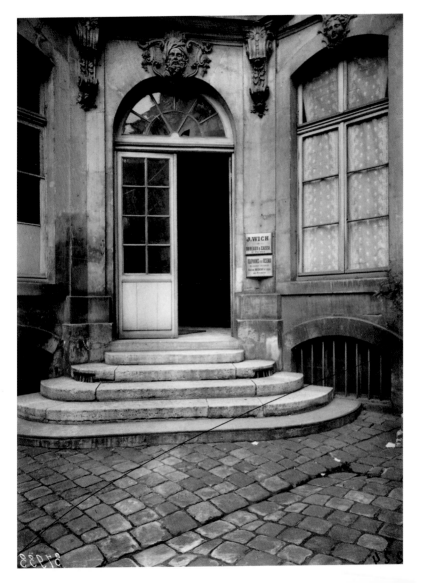

Versailles, Park, Paris, 1901. The château and park of Versailles became one of Atget's favourite locations in the environs of Paris, and he photographed there at frequent intervals. However, it was not so much Hardouin-Mansart's palace that engaged him photographically, but Le Nôtre's gardens. Here, between 1901 and 1906, Atget learned how to photograph space, resolving 'the cacophony of the world into harmonious visual phrases', as Maria Morris Hambourg has written. He treated the vast theatrical spaces as the *mise-en-scène* for a grand entertainment on the subject of French mythology – which was exactly their public function. In Atget's hands, though, myth became less certain and pompous, and something much more mysterious, dark and ineffable.

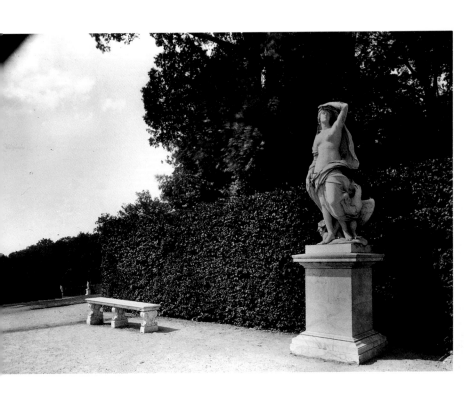

Versailles, A View from the Parterre Nord, Paris, 1903. Atget seemed some what uncertain what to do with Hardouin-Mansart's gross edifice, and none of his images of the château itself rise above the commonplace. This is the most interesting by far, because Atget attempted to dramatize his sky by 'burning in' giving additional exposure to that part of the image during printing. Of the several prints known of this image, this is the most successful, as others show that he tended to 'burn' château as well as sky and overcook the result. As he printed out his negatives by contact in specially made printing frames, such a procedure was highly contingent and tricky at best, and he seems not to have repeated the experiment.

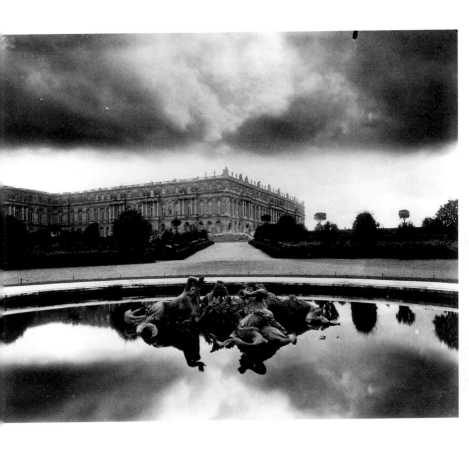

Au Tambour, 63 quai de la Tournelle, Paris, 1908. Another image from Atget's extensive series on shopfronts, and one of his greatest because we have a rare self-portrait, complete with camera, in the window reflection. The viewer is left to consider how serendipitous or how considered was the comical conjunction of the curious shopkeeper's head on the photographer's shoulders. Whether by accident or design, this remains one of his most curiously affecting images, one of the few pictures in Atget's vast oeuvre where we come close to him in a physical, as well as a psychological sense. It is also, one might add, a masterpiece of composition. Like most examples of shopfronts with grilles, this splendid example unfortunately has been demolished, replaced by an Australian tourist boutique.

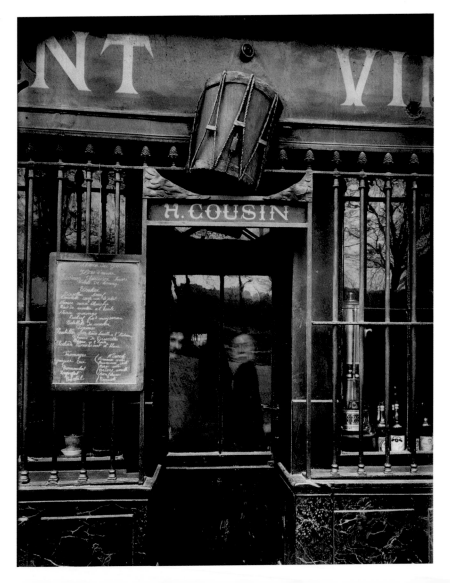

Interior, House of Mr A, Industrialist, rue Lepic, Paris, 1910. In 1910 Atget made a series of domestic interiors which he sold, in album form, to both the Musée Carnavalet and the Bibliothèque Nationale. The dwellings selected range from those of the *haute bourgeoisie* (including the sumptuous apartment of actress Cécile Sorel, star of the Comédie-Française), to the *petite bourgeoisie* and the working class (including Atget's own modest but comfortable flat in Montparnasse). Molly Nesbitt has suggested that this work, in particular, shows the politically radical Atget, and that these photographs ask their viewers 'to see style as a function of class'. She perhaps overstates the case somewhat, but Atget was certainly a photographer with a decidedly sharp propensity for social history.

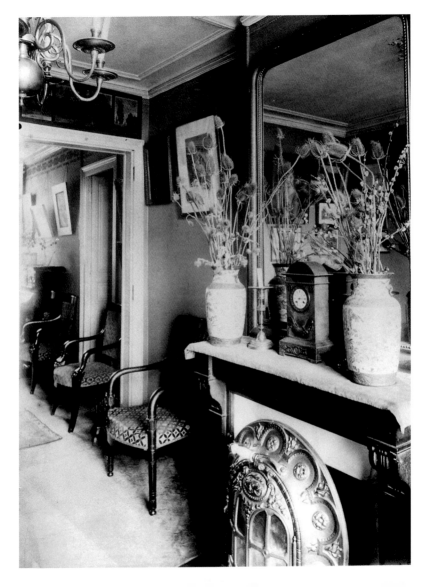

The Drawing Room of Mme C, Milliner, place Saint-André-des-Arts, Paris, 1910. The 'Interiors', whether or not they were intended to function as a discreetly encoded polemic, are as rich in social detail and aesthetic interest as his more celebrated shop window exteriors, and deserve to be better known. Atget made two negatives of this milliner's salon in the place Saint André des Arts on the Left Bank. The difference between the two photographs was half a turn of the camera, but he included both in his album. The only justification for this narrative tautology, for both tell the same sociological tale, would seem to be nothing more than the fact that both were such striking images in visual terms and worthy of inclusion on that basis.

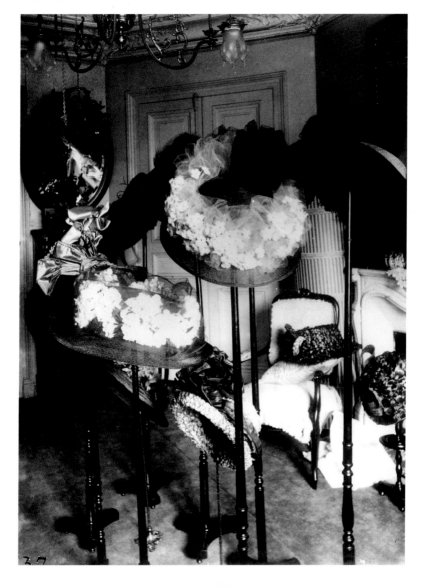

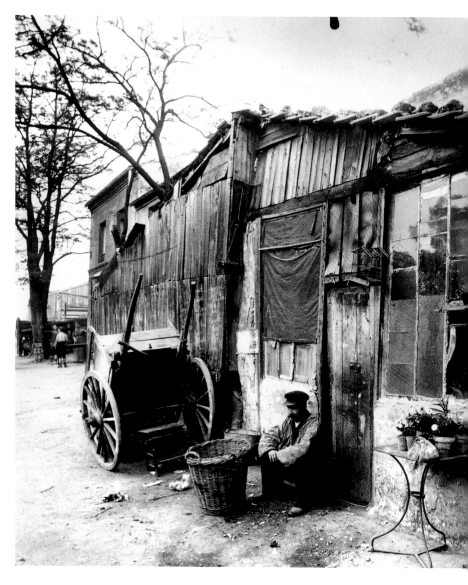

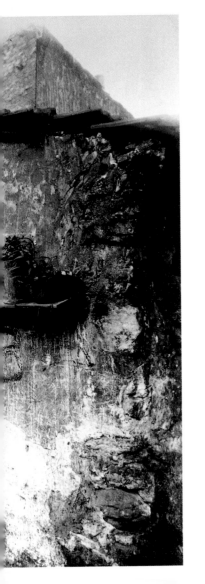

(previous page) **Rag-picker's 'Villa', boulevard Masséna, Paris, 1910.** Between 1910 and 1913 Atget made a particular study of a singular *petit métier*, the *chiffonniers* (rag-pickers), collected together in his album *Zoniers*. In 1903 it had been estimated that some 5,000–6,000 Parisians were dependent upon sifting through the rubbish of the bourgeoisie for anything that could be resold. To Karl Marx, the trade represented the ultimate degradation of the worker under capitalism. To certain middle-class writers, the rag-picker was sentimental embodiment of freedom, a kind of free-spirited, irresponsible Jack the-Lad. Atget's grim, clear-eyed, unsparing documentation makes abundantly clear his socialist opinion on the matter, his use of the word 'villa' in his title bitter irony.

Entrance to the Courtyard, 9 rue Thouin, Paris, c.1910. Many of Atget's image portray the walking experience, but generally they invite a somewhat leisurely contemplative stroll. Similarly, the sense of space in an Atget image, even one describing an enclosed area, is usually expansive rather than restrictive, offer ing a choice of ways by which the viewer may visually enter or leave. It also provides a psychological sense of ease and intimacy, a feeling that we might like to inhabit the picture. In this image, however, one of the most abstract ever made by Atget, we are visually impelled to hurry down this grim passage before its dark, dank walls press in on us, and escape gratefully into the luminous sanctuary of the courtyard beyond.

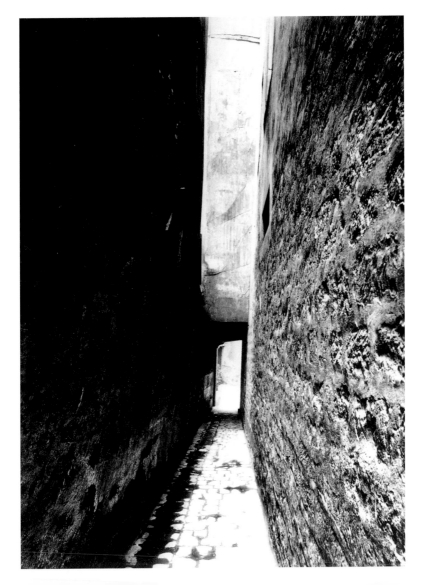

Porte de Ménilmontant, 20e, Fortifications 'Guinguettes', Paris, c.1910.
Atget's documentation of the rag-pickers was part of his record of the *Zone militaire*, a belt of land around half a kilometre in width, directly outside the city walls, which clearly fascinated him. The *Zone* was intended to facilitate the city's defence; permanent structures were prohibited within it. Literally a no-man's-land by official designation, it had become a haven for the outsider, occupied by the makeshift hovels of the rag-pickers and others, and the caravans of the gypsies. It was also dotted with these basic outdoor cafés, known as *guinguettes*, for working-class itinerants – often set, like this example, among the scruffy trees and vegetation that made the *Zone* an unofficial, somewhat dangerous proletarian park.

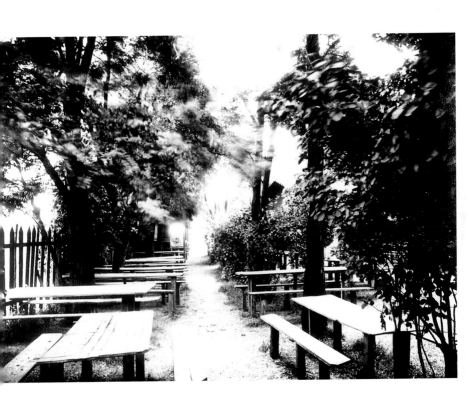

91, rue de Turenne, Paris, 1911. Another example of Atget's 'bread-and-butter' work, photographing the staple fare of his commercial practice. Yet, as John Szarkowski has noted, the photographer 'was rarely particular as to documentary protocol or finish'. Certainly, a more useful record might have been made if Atget had chosen a slightly different angle. Szarkowski also records that this particular image took the eye of the Surrealists. It was published in the magazine *La Révolution Surréaliste* in December 1926. Julien Levy, who later bought half of Atget's archive in concert with Berenice Abbott, the first and most consistent advocate of the photographer's worth, considered that 'its pregnant emptiness and serpentine movement toward a hidden place achieved a subtle mystery'.

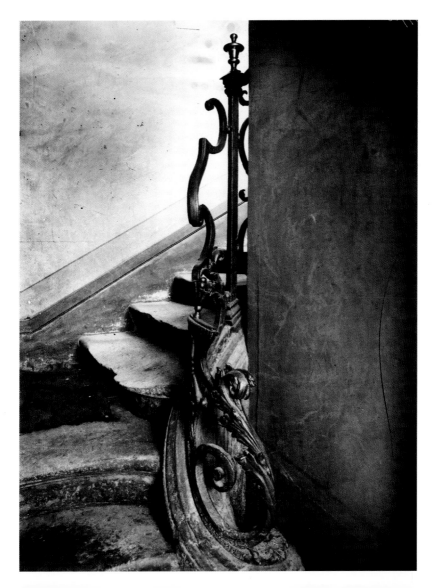

Courtyard, 21 rue Mazarine, Paris, 1911. A notable feature of Atget's imagery is that it was generally shot from eye level, and took in an 'ordinary' point of view. When photographing architecture, he frequently could not raise his lens panel high enough to take in the top of a building without tilting – a serious professional transgression. Or else he raised it too far – beyond his lens' circle of cover – and produced an arched cut-off to the image in what would be considered another example of careless technique. Here, in this view of a gloomy, run-down courtyard in the rue Mazarine, he avoided these problems by shooting from an upper storey, an unusual occurrence in his work.

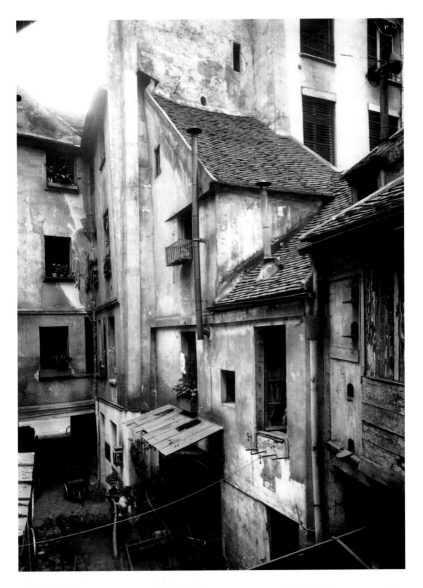

Courtyard, 41 rue Broca, Paris, 1912. The classic Parisian townhouse; devel
oped around a courtyard, entered through a large blank door, producing an oasi
of tranquillity and privacy beyond. Inside these courts, the 'real' life of Paris
was lived; thus they were a prime 'Old Paris' concern and a favourite subject o
Atget. He photographed not only grand examples, but the more picturesqu
courts inhabited by the working class, such as this classic image from the rue
Broca. In its attentive depiction of light, texture and telling detail – such as th
carpet hanging in a window opening – not only the claustrophobic life of the
crowded building is evoked, but also, we fancy, its myriad harsh sounds and
insalubrious smells.

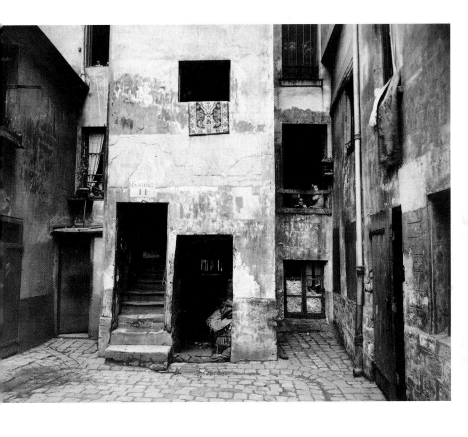

Inside a Rag-picker's House, boulevard Masséna, Paris, 1912. Atget's series o
the rag-pickers – the *Zoniers* album he sold to the Bibliothèque Nationale
though characterized by what John Szarkowski termed his 'perfect clarity an
philosophical disinterest', would seem the most politically motivated examples o
the photographer's work, precisely because of these unemotive, contemplativ
qualities. Atget's camera took in everything and spares us nothing; the need t
carefully structure the image seems not only unnecessary, but inappropriate. I
is perhaps pertinent as well as sobering to note that, in this eminently unaes
thetic and therefore moving view of a rag-picker's interior, that this is possib
where they not only sorted through the discarded detritus of the middle classes
but also lived.

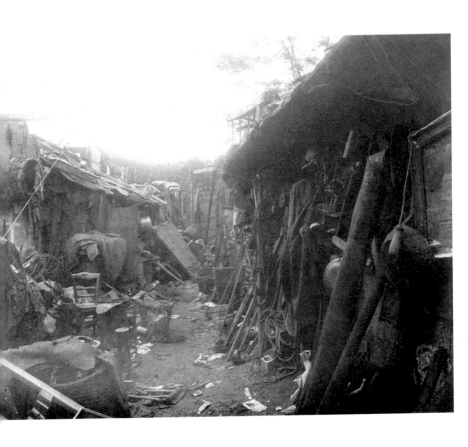

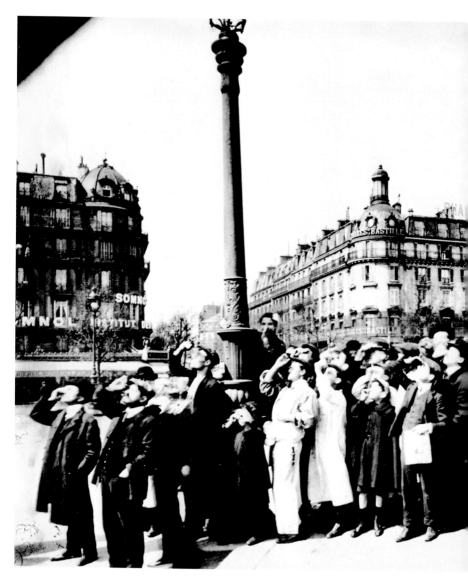

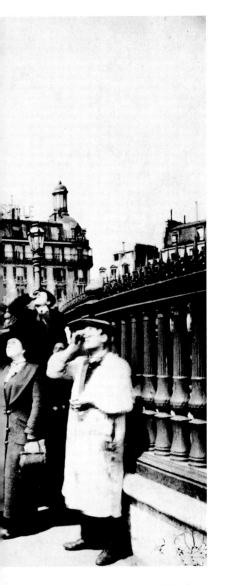

(previous page) The Eclipse, Paris, 1912. Long after he realized the futility of trying to make instantaneous pictures of people on the street with a large view camera, Atget could not resist making several negatives of a crowd watching an eclipse. Despite some inevitable blurring this image of a crowd staring with avid concentration at an event we cannot see is totally compelling. It is, perhaps Atget's best-known street image, largely because it was selected for its evident surreal qualities by Man Ray and reproduced on the cover of *La Révolution Surréaliste* in June 1926. Typically, the modest, retiring Atget would not countenance a byline. 'Don't put my name on it,' he allegedly said. 'These are only documents I make.'

Boulevard de Strasbourg, Corsets, Paris, 1912. This is one of the best-known of all Atget images, and one of his best shop window pictures; an early instance of his fascination with store mannequins which would prove such a fruitful area for him in the 1920s. Like the previous plate, it was one of those Atget photographs to attract the approbation of the Surrealists in the mid-1920s. It is a fine example of how the photographer, by subtle placement of the camera at a slight angle, was able to enliven the frame visually and thereby create the illusion of animating inanimate objects. One also suspects that this particular image appealed so much because it cheerfully catered to certain masculine fancies about Paris.

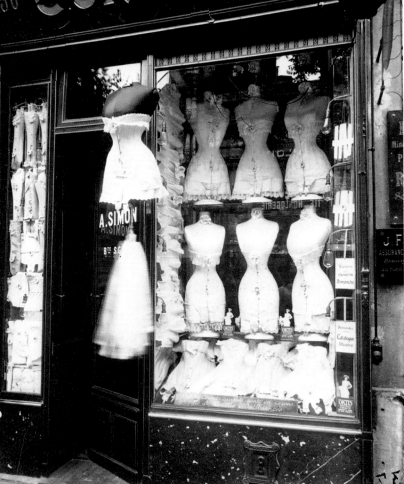

Courtyard, 22 rue Quincampoix, Paris, 1912. The rue Quincampoix is a dark narrow street which runs parallel to the boulevard de Sébastopol. In Atget's day it was known for its prostitutes. Today, because of its proximity to the Beaubourg Centre, it is known for its art galleries, although the *filles* have not moved too far away. John Szarkowski notes that Atget photographed this court twice, in more or less the same way, at an interval of two years. He muses upon the reasons for this apparently illogical repetition, but reaches no conclusion. It is one of the most notable features of Atget's work that he was drawn back to certain places for, we may surmise, not just professional but also personal reasons.

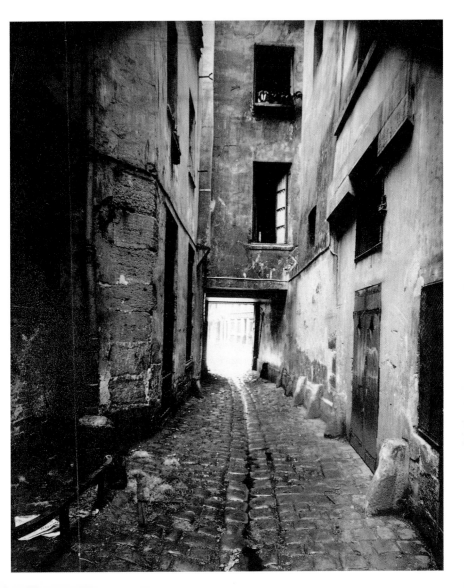

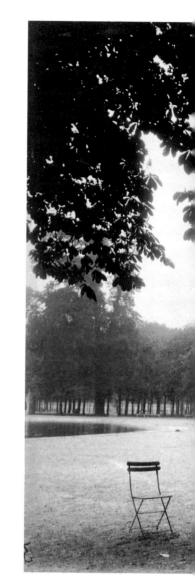

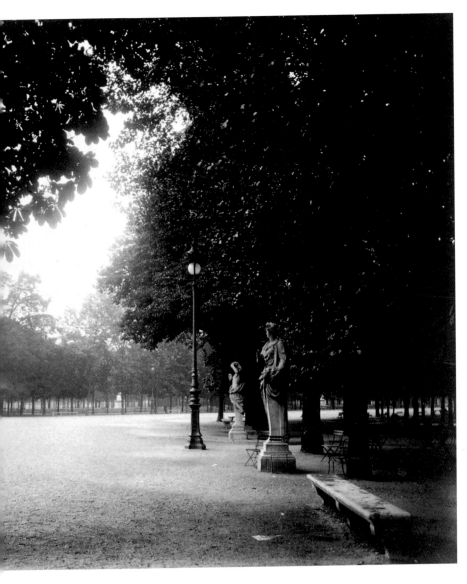

(previous page) Tuileries, from the Concorde Side, Paris, 1912. In 1912 Atget was invited by Marcel Poëte of the Bibliothèque Historique de la Ville de Paris to photograph the Tuileries Gardens, a commission he seems to have accepted with reluctance. Throughout his career, he preferred the freedom of working on 'spec'. 'People do not know what to photograph,' he is said to have remarked when asked why he generally eschewed assignments. Perhaps his misgivings were transmitted into the Tuileries work. Some of the results were rejected on technical grounds, and Atget, his pride dented, never again worked under supervision. One assumes that this quite masterly image was not among those rejected – despite the photographer's blatant placement of the chair on the left.

Porte de Gentilly – Fortifications, Paris, 1913. In a recent study, photographic historian David Harris has demonstrated how Atget worked systematically in series, taking a number of topographical views down a street, or methodically surveying a building and its decoration. The discipline inculcated by architectural photography stayed with him when he photographed rather more personal subjects. In his *Zoniers* images, he followed a series of desultory footpaths, making a group of pictures that seem to describe little of documentary or historical significance, but which demonstrate a penchant for making images out of 'nothing', and vividly evoke a sense of place and the intense feeling of following a trail, not knowing where it will lead.

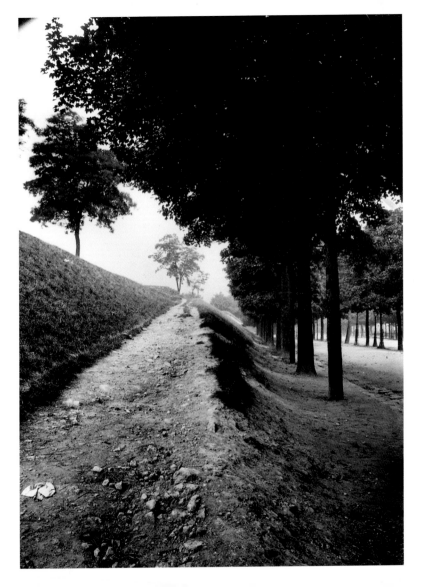

Porte de Bercy – the P.L.M.Leaving Paris, boulevard Pomatosski, Paris, 1913

Professor Tod Papageorge has stated that the best of Atget's pre-World War I
pictures are 'charged with an animal attentiveness (created as much by Atget's
uncanny sense of camera placement as by whatever feeling he may have had for
his subjects)'. Certainly, the subject of this image from the 'Zoniers' series
would seem to be even more nominal than his path sequence, the picture's point
being camera placement rather than anything else. In short, it would seem to be
more about how Atget could make a picture out of the most unlikely subject –
that gawky pole – than any serious attempt to document the railway tracks lead-
ing out of Paris at Bercy.

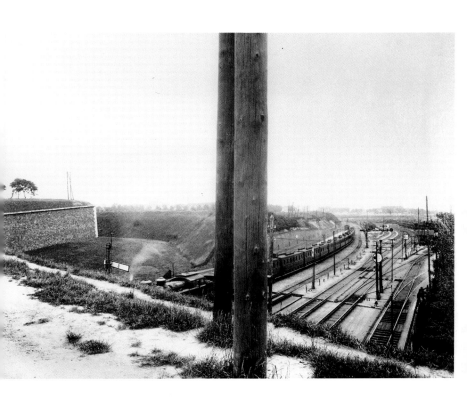

The Old Passage du Pont-Neuf, Paris, 1913. In order to establish Atget' credentials, the historical value of the more documentary aspects of his wor should not be underestimated. He made an inestimable record of a number c Parisian *quartiers* under threat from the demolition contractor's ball, especiall on the Left Bank and around the old medieval heart of the city. Indeed, thoug we fondly imagine Paris as a city that changes less than most, much of wha Atget photographed has disappeared. In this view of the demolishing c an old building near the Pont-Neuf, documentation and art happily co-exis in what must be one of the most graceful photographs ever made of an ac of destruction.

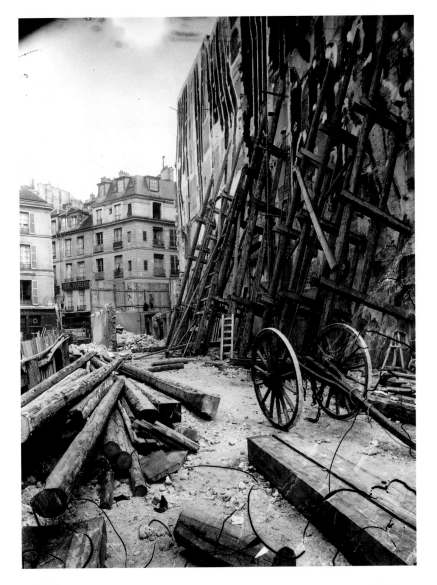

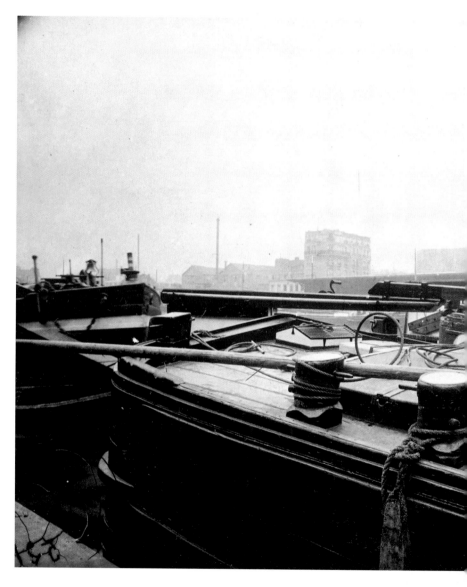

(previous page) Bassin de la Villette, Paris, c.1913–25. The Bassin de la Villette is a holding harbour on the Canal de l'Ourcq, which links the Seine to the Marne. The hustle and bustle of life along the *quais* and canals of Paris was always a subject that drew Atget although, as usual, he seemed interested in the *mise-en-scène* rather than the play itself. This stark, elegant view cannot be dated with certainty, but John Szarkowski ascribes it to the latter end of the date shown on stylistic grounds. 'The highly eccentric character of the picture, which shows us nothing clearly except the grubby and adventurous mood of a working port, is characteristic of the photographer's late work.'

Old Courtyard, 22 rue Saint-Sauveur, Paris, 1914. Of all Atget's views of old courtyards, this seems one of the most bleak and forbidding, describing a place where one would not care to live – although an alternative view of the same court tells an altogether different story. In purely aesthetic terms, however, in its superb handling of line, this is surely one of the photographer's finest images. One suspects that Atget was drawn to this grim corner, not simply because of its perceived social meaning, but because of its potential for picture making. As Maria Morris Hambourg notes, the geometric configuration of Atget's images 'sometimes becomes so emphatic that, were the subject unintelligible, the photographs could stand solely on the strengths of their structures'.

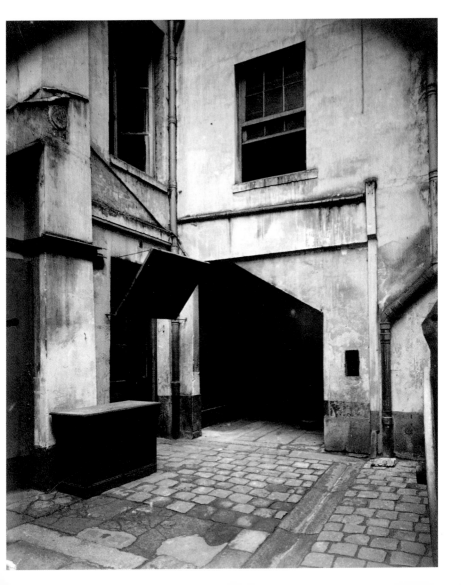

Cour de Rohan, Paris, 1915. The Cour de Rohan (or Rouen) consists of thre interlinked courtyards just off the boulevard Saint-Germain. It remains a plac which, despite its location close to one of the city's main thoroughfares, ha a secluded and semi-rural aspect. It could hardly fail to draw Atget, and h documented its tranquil attractions in a systematic series in 1915. This view of cat, sitting in front of a foliage-covered doorway, must lay claim to being one c the most charming of photographs in an oeuvre which frequently beguiles amazes and moves, but seldom charms. Today, the scene remains unchangec except that the sculpted head and niche above the door has been replaced b a window.

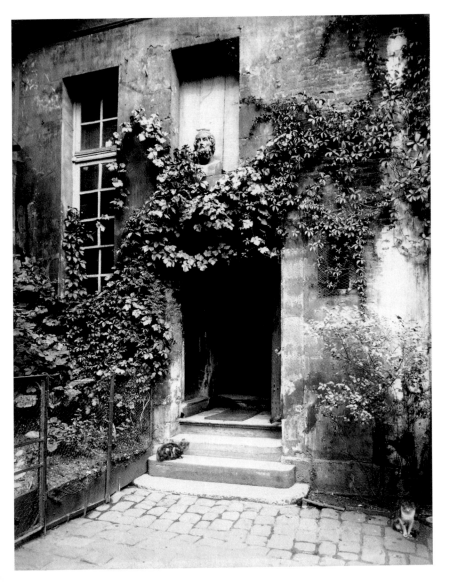

Old Windmill, Charenton, Paris, 1915. Throughout his career, Atget continued to make regular excursions into the Île de France to photograph a great variety of rural subjects – plants, trees, village and farm architecture. It seems absurd to postulate, when faced by an image such as this view of the old mill a Charenton, that Atget had no interest in the aesthetics of photography. Perhaps that interest extended simply to doing the job as best he could. But looking a the several negatives he made of this subject, it is difficult to believe that he did not take delight in ordering this particular picture's visual complexities, with its alternative denial and granting of spatial depth.

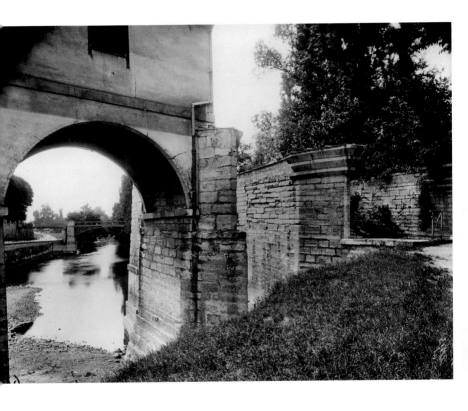

Saint-Cloud, Paris, 1915–19. Following World War I, Atget's practice change drastically. Put simply, one might say that he began to photograph more for him self than others — a crucial change which fuels the notion of 'late' Atget. As To Papageorge has written, 'It is only with his late work that the lithe, pre conscious energy which had informed his earlier photographs is transmute into an active authorial presence located within the pictures themselves.' Hi series on reflections in the great pond at Saint-Cloud, made obsessively over a number of years, would seem to bear this out. There seems little practica reason to hammer away at this minimal subject, except the urge to make a visuall coherent — and wonderful — image out of almost nothing.

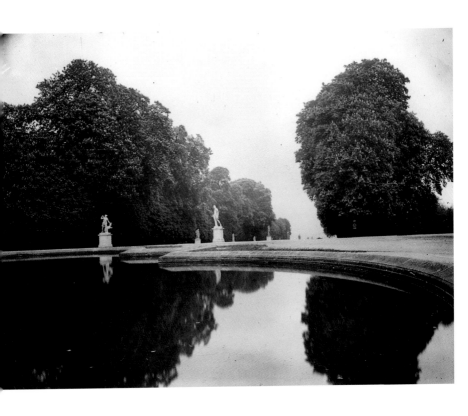

Rue Perrotin, Châtillon, 1915–19. One of the salient characteristics of Atget seems to have been his willingness to allow intuition to guide him in a way that many fellow professionals would have deemed eccentric. His work is marked by a readiness (photographically speaking) to 'stop and smell the flowers along the way'. John Szarkowski mentions that, on his several visits to Châtillon, Atget could have walked directly from the railway station into town by the main street but chose the more scenic, indirect rue Perrotin, where he discovered not only this superbly gnarled wall and mysterious gates, but a number of other first rate images.

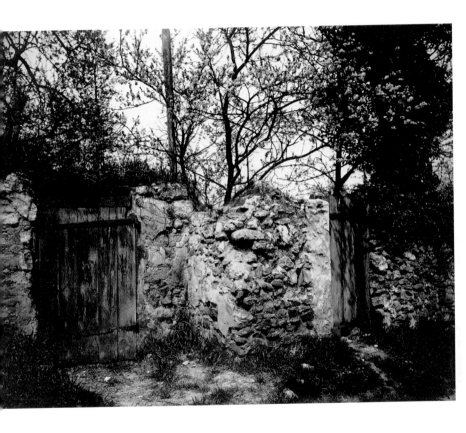

Montmartre, 18 rue du Mont-Cenis, Paris, c.1921. Atget did much of his finest work sniffing out disregarded territories. This example comes from another area he visited on numerous occasions during the 1920s. By then, most of the serious artists, who had made Montmartre the byword for *la vie de bohème*, had moved south to Montparnasse, and Atget was not interested in the clichéd view of the third-rate Sunday painters who remained. As ever he ploughed his own furrow, using this grubby yet evocative court for a theme familiar in his work, a gently ironic meditation upon the heroic and the pastoral flourishing in an unlikely setting.

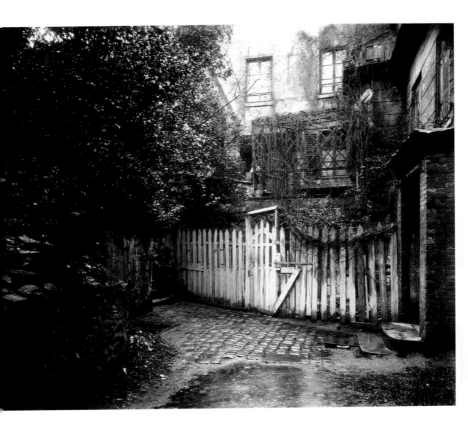

La Villette, Prostitute, Paris, 1921. In 1921 Atget was commissioned by the painter André Dignimont to make a photographic series on prostitutes and brothels, always a subject dear to the Frenchman's heart. His portraits of *filles publiques* standing nonchalantly before their workplaces are as baldly matter of fact as his 'Petits Métiers' of two decades earlier, and are among his best known images, probably because his portraits are so rare. In this example, John Szarkowski has noted that 'the elongation and the closeness of the woman's right leg, and the speed with which the rest of her and the street fall away from the viewer, seem to produce a perfect graphic expression of both her superficial availability and her profound remoteness'.

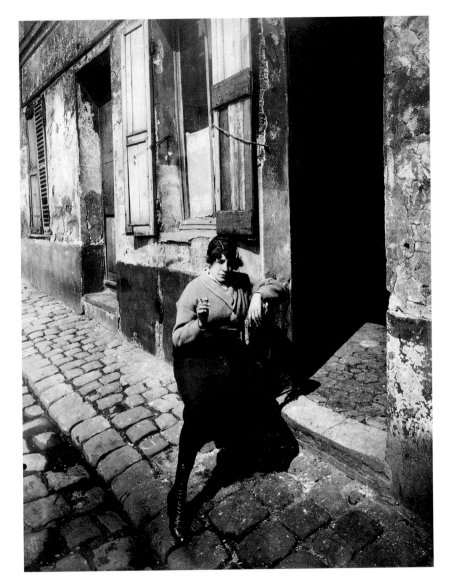

La Villette, rue Asselin, Prostitute in her Doorway, Paris, 1921. Atget's commission for Dignimont seems to have been abandoned fairly quickly, perhaps because the photographer's quiet, yet painfully truthful approach did not satisfy his client's more sentimental preconceptions. However, he may have pursued the theme a little further on his own behalf. There are a number of nudes, possibly taken in brothels, which have been dated to 1925–6. These are brutal, even pornographic in tone, with no pretensions to photographic good manners. The petering out of this project seems unfortunate for, as John Fraser contends what remains of Atget's only real foray into social portraiture reveals that, by virtue of his implacable honesty, he was potentially one of the greatest of photographic portraitists.

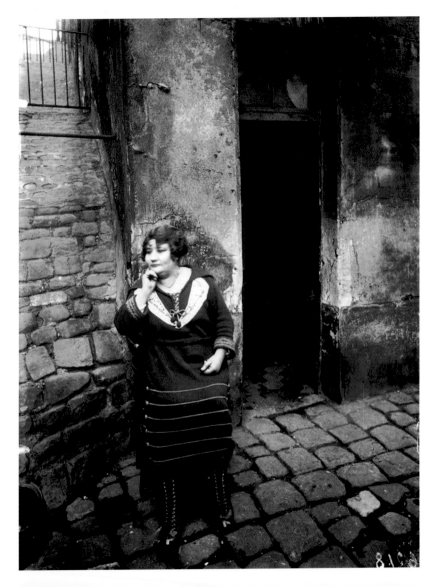

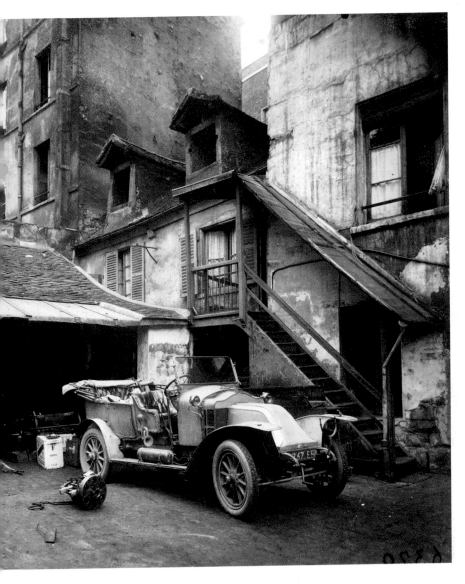

(previous page) Courtyard, 7 rue de Valence, Paris, 1922. It is often blithely assumed that Atget's work was nostalgic in tenor because of his concentration on old and picturesque Paris, rather than on modern life, but this is a misapprehension. What he tended not to photograph was Haussmann's Paris – fashionable, *haut bourgeois* Paris. But in the older streets and *quartiers* he frequented, the life of the *petite bourgeoisie* and working classes is seen in abundance. Atget's imagery reeks of it, as in this view of a repair shop in an old court, with its magnificent, unexpected Renault touring car. Evidently, this picture's success persuaded Atget, clearly something of a Luddite, to make further images in which the motor-car appears – albeit discreetly.

Saint-Cloud, Paris, 1922. Compare the elegant, but relatively conventional view of Versailles taken in 1901, with this picture from Atget's late 'Saint-Cloud' series. It is like comparing Beethoven's 'Razumovsky' with the late string quartets. If one becomes tempted to pour scorn on the theory of Atget's late flowering as an artist, an image such as this might surely persuade otherwise. The solid reality of Versailles has been transformed into pure space and visual illusion. If the picture is turned upside down (the way he would view it on his camera's ground-glass screen) the almost unprecedented daring of Atget's conception becomes more readily apparent. As John Szarkowski has remarked of more than one Atget image: 'What did he think he was photographing?'

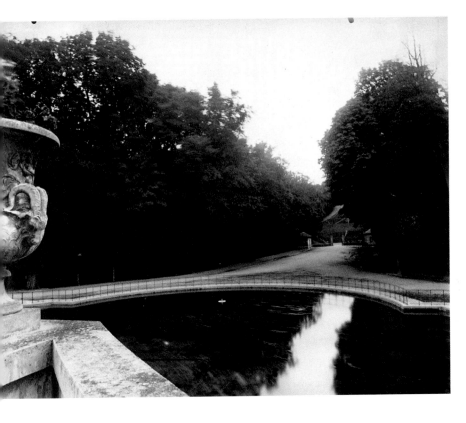

Petit Trianon (Pavillon Français), Paris, 1923—4. For those who believe Atget did not know precisely what he was doing (a quite different question from the one asked on page 97), this image might be cited as especially instructive. What seems to be a sizeable lake right in front of the Pavillon Français in the Petit Trianon is actually a small pond, at some remove from the pavilion. The photograph is a fiction, a fabrication. To create this floating effect, Atget must have placed his camera almost at water level to take full advantage of his wide-angle lens – a feat that must have involved a great deal of awkward tripod manipulation; and one he replicated over several different negatives from slightly different viewpoints.

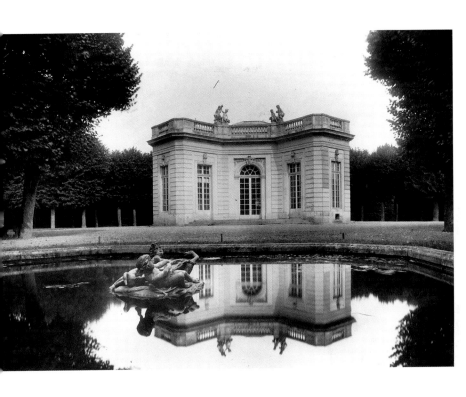

Saint-Cloud, Paris, 1924. When Edward Weston was given a copy of Pierre MacOrlan's pioneering *Atget* monograph in 1930, his views were mixed. He praised Atget for his honesty as a photographer, but also expressed his disappointment at what he considered the lack of conscious artistic mediation in the work. 'I had expected a flame,' he wrote, 'but found only a warm glow.' Weston admired this Saint-Cloud tree root, however. It paralleled his own attempts to abstract nature. Yet, in comparison with the self-regarding Weston, Atget's image seems so much less abstract and arty, much more down-to-earth and concerned with life rather than self-expression, defining the tree's place in nature rather than in art.

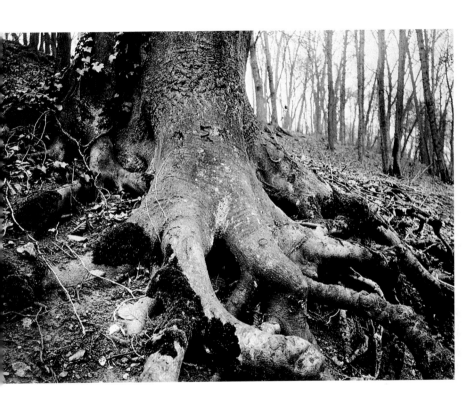

Trianon, Versailles, Paris, 1923−4. Atget was a profoundly serious and sober photographer. And at times (such as in his images of the rag-pickers' hovels) possibly an angry one. Bitter-sweet is a word frequently used to describe his work. He was also, at other times, a joyful and even humorous photographer taking evident delight in the serendipitous visual oddities and incongruous juxtapositions thrown up by his camera − hence his adoption by the Surrealists. Here, one has to conclude that the primary reason for taking this picture was not so much the documentation of two Versailles statues, but a playful aside at human relationships. There is also the matter of a relatively rare excursion into chiaroscuro, but this may simply have been an exposure miscalculation.

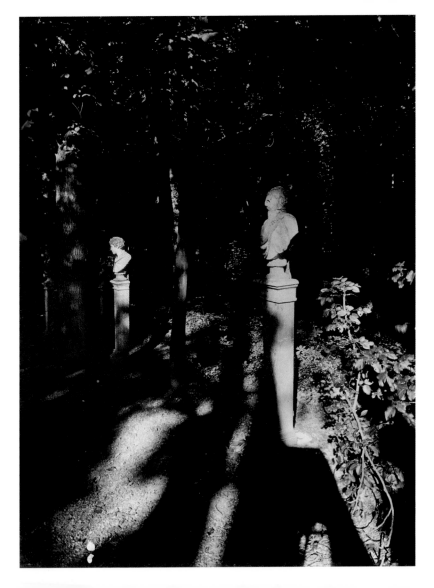

Parc de Sceaux, June, 7 a.m., Paris, 1925. In 1925, Atget made a group of pictures in the abandoned, decaying park at Sceaux, designed by Le Nôtre, on the southern outskirts of Paris. Like the late work from Saint-Cloud, these are among his most felicitous pictures; nominally imprecise, irrational in spatial description, thoroughly elegiac in tenor. Here, Atget has photographed a statue from the rear, shooting into the light (he also made an only slightly more conventional front view), showing two stone figures huddled together, as if to resist culture's reclamation by unruly nature. Their resistance was rewarded. Some four months after Atget began photographing this eloquent ruin of a landscape, it was transformed back into a handsome, manicured public park reflecting Le Nôtre's original grand concept.

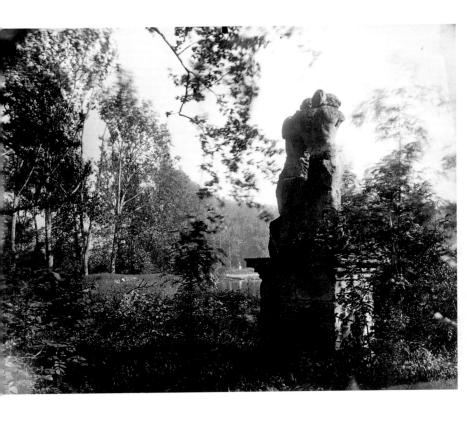

Parc de Sceaux, March, 7 a.m., Paris, 1925. This seems to be one of the most purely formalist images ever taken by Atget. As happens frequently when viewing these late series images from Sceaux or Saint-Cloud, one cannot resist the question – if we are dealing simply with a workaday, commercial documentary photographer, or even a blessed *naïf* – Why? As with that telegraph pole at Bercy, Atget clearly tripped his shutter with intent, for one does not casually expose large glass-plate negatives. It requires quite a force of will to play serendipitous games with a large view camera and expensive plates, yet, on the evidence of such an image, Atget was a profoundly experimental photographer.

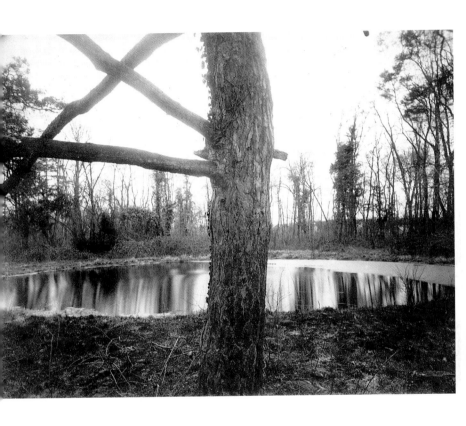

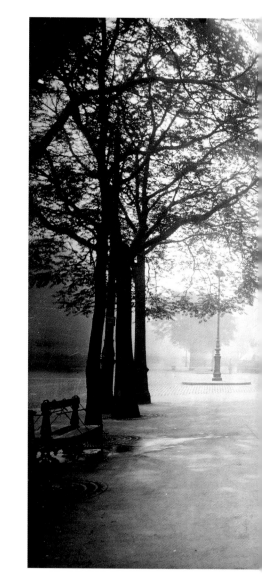

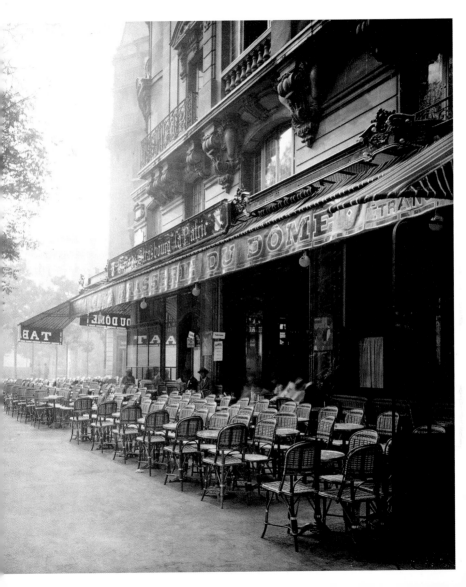

(previous page) **Le Dôme, boulevard du Montparnasse, Paris, 1925.** Joh
Fraser has remarked that the photographer's city was a place 'in which on
moves around, consumes things, seeks mental refreshment and rests'. Sma
wonder, then, that the Parisian café, from humble *guinguette* to modest bar, t
the rather grander establishment pictured here, was a central feature in hi
work, the epitome of the French urban experience. Le Dôme, Montparnasse'
celebrated brasserie, was but a few steps from Atget's apartment, saving hir
his usual back-breaking journey with his heavy equipment. Perhaps that is wh
this image of the restaurant, with its sprinkling of early morning customers
bathed in a soft summer light following a shower, is so redolent of well-being
celebration and keen anticipation.

Place Pigalle, Paris, 1925. Comparing this late cityscape with some of his fines
early topographical views in similar vein (such as pages 29 and 31), there ar
both similarities and differences. Atget was adept at charging the frame wit
kinaesthetic energy almost from the start, but in the late pictures his authorit
seems at once less apparent yet more absolute. Every square centimetre of th
picture space, from edge to edge, works for its living, yet this compositiona
mastery looks almost casual, accidental even; less a product of conscious effor
and more of an inevitability, whether the picture is chaotically crowded o
empty, as in this view of the Place Pigalle.

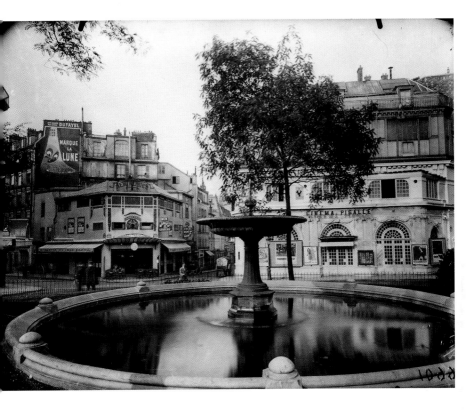

Fête du Trône, Paris, 1925. From the very outset of his Parisian career, Atget photographed street entertainment, from the *Théâtres de Guignol* (Punch and Judy shows) to the extensive series he did on fairgrounds in the 1920s. His whole oeuvre, indeed, is a celebration of street theatre. This picture is one of his most celebrated, at once a straight observation of a fairground stall yet also a surreal collage of which Max Ernst would have been proud; a play on scale, illusion and bitter-sweet association. In some ways, it seems an atypical Atget picture, slightly arch, a little self-consciously arranged, yet it remains one of his most affecting images, exemplifying Tod Papageorge's assertion that 'there is nothing so mysterious as a fact clearly stated'.

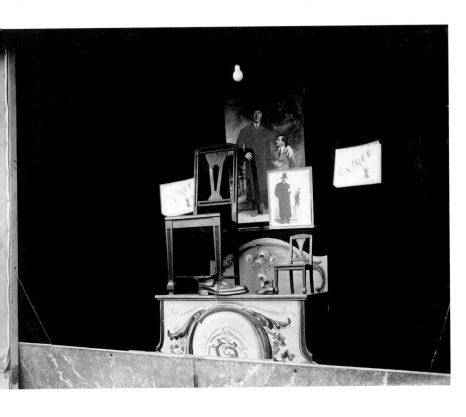

Rue Mouffetard, Paris, 1926. The essential quality of Atget, argues John Frase
(and he is surely right), is that he gave us 'certain basic aspects of the city a
they impinged on someone actually living in it in an ordinary way'. Consumeris
was always an important aspect of this for the photographer, partly because
was clearly part of urban theatre, possibly because the political Atget wa
acutely sensitive to the oil that greased the city's engine. In his final two year
he made a series on shop displays that contains some of his finest imagery. I
the previous image seemed arty, this seems rather artless. Yet both are product
of the same mastery, an ineffable combination of intuitive recognition and ruth
lessly considered framing.

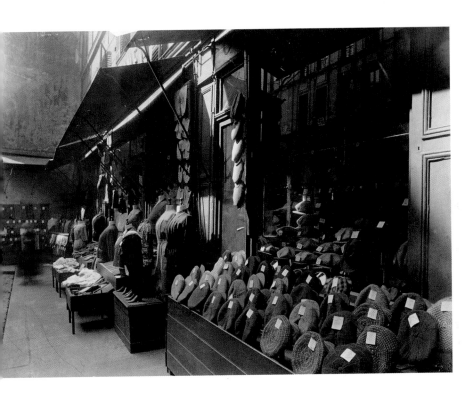

Avenue des Gobelins, Paris, 1926–7. These disembodied suits of clothes obviously fascinated the Surrealists, and evidently meant more to Atget than standard documentary fare, for he returned to the theme – to the same shop even – with an obsessiveness that marked his most fervent predilections. These were among the first of his images to become widely known, and remain so mainly because they have become one of modern photography's primary clichés. They are a subject to which the photographic neophyte will immediately turn when trying to be creative; to investigate how the straightforward record can function as such, yet become a vessel for metaphorical meaning. Nevertheless, as John Szarkowski observes, though these images have spawned a million copies, the originals easily retain their disturbing power.

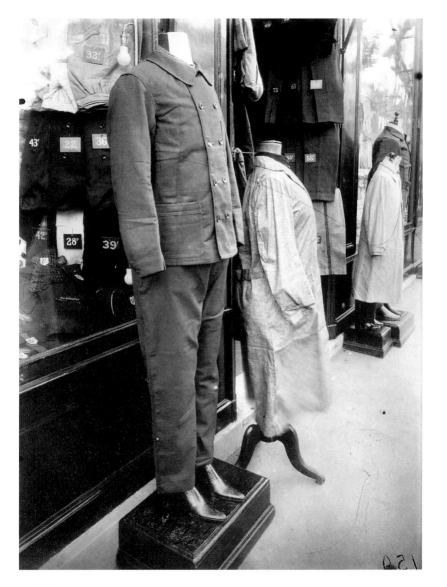

Moulin-Rouge, Paris, 1926. When Atget photographed the Moulin-Rouge in his usual matter-of-fact fashion, glowing against the light and filtered through screen of trees and street furniture, he did not suggest the gaudy theatre of tarnished dreams beloved of post-Impressionist painters and Hollywood film producers, but something more homely and down-to-earth. Something more photographic, in fact, than painterly or cinematic, despite the mediating veil. By this time, Lautrec's and La Gouloue's Moulin had gone, burnt down in 1915, and the celebrated cabaret – rebuilt – had become a cinema as well as a music hall. The Belle Époque had given way to the Jazz Age.

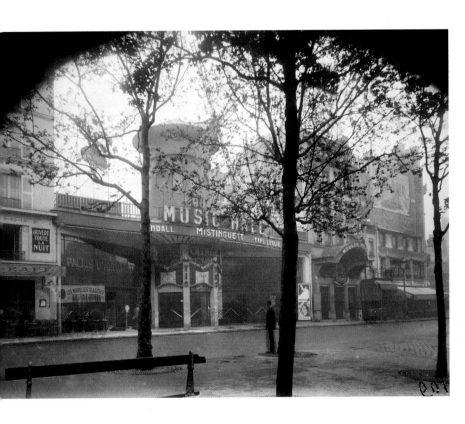

Saint-Cloud, March, 9 a.m., Paris, 1926. There are few Atget pictures less documentary and more existential in tenor than this masterly, shimmering transcription of a misty spring morning in Saint-Cloud, looking down upon the very pool where the photographer had toyed with reality and reflective illusion some years previously. It is tempting to regard this mellow view as Atget's valedictory image, but this was a March, not a December morning, so perhaps the reading of Tod Papageorge is more fitting: 'In the photograph of a statue, in shadow, from behind, as its right arm reaches up into a neighbouring tree's tangle of new buds, the life of both [art and nature] join in one vital line.'

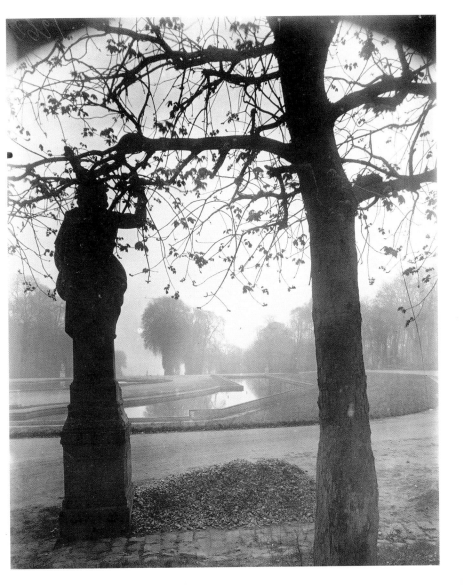

Quai d'Anjou, April, Paris, 1926. Foggy mornings evidently cast their spell o
Atget in the mid-1920s and drew him, not only to Saint-Cloud or Sceaux, but t
territories closer at hand, especially along the banks of the Seine, favoure
stamping grounds for more than twenty years. Between 1923 and 1926 h
photographed once more along the *quais*, a succession of evanescen
mysterious views that differ quite radically from the hard, bright pictures h
took of the same subjects in the first decade of the century. This hushed
contemplative, impeccably poised image surely bears out Arthur Trottenberg'
assertion that Atget 'was concerned with the pulsation of life in a city whic
once had time to nourish its inhabitants in more meaningful relationships tha
pertain today'.

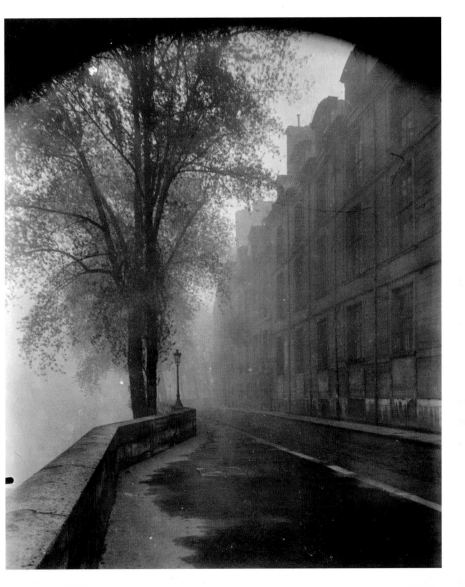

Saint-Cloud, June, Paris, 1926. Those who have not lugged a large view camera and attendant baggage around can have little idea of the effort involved. Atget was sixty-eight years of age when he trudged up the hill at Saint-Cloud to the reflecting pools, the area which had given him some of his finest images, looking over the city with which he will always be inextricably linked. We can only guess what compelled him to these herculean labours at such an age, but we certainly can marvel at it. The final word must surely rest with a fellow photographer. When asked why Atget was so important, Charles Harbutt's reply unerringly found the heart of the matter, 'Because of where he stood.'

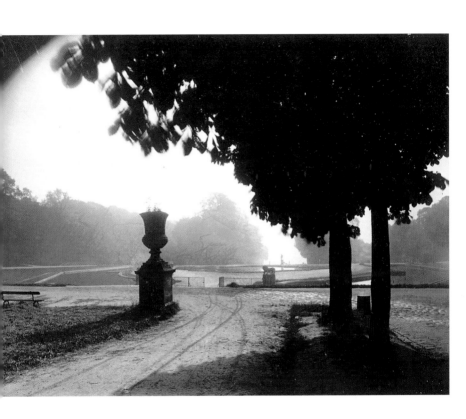

1857 Born 12 February, Libourne, Dordogne, son of Clara and Jean Eugèr Atget, a carriage maker.

1859–1878 Family moves to Bordeaux, but he is orphaned at an early age ar brought up by maternal grandparents, Victoire and Auguste Horlogier

1878 Begins National Service in 62nd Infantry Regiment, but applie to National Conservatory of Music and Drama, Paris. His applicatic is rejected.

1879 Second application to Conservatory is successful. Whilst still servir in the army, he is assigned to the class of the famous actor Edmond Go

1881 Fails to graduate from the Conservatory. Deeply affected by the death both his grandparents the same year.

1882 Mustered out of the army, he joins a touring troupe of actors, playir unglamorous 'third roles'.

1886 Meets actress Valentine Delafosse Compagnon, who becomes h lifelong companion.

1888 Frustrated by lack of success in his acting career, he moves Department of the Somme and begins to photograph with a large vie camera (18 x 24 cm).

1890–1891 Now settled in Paris, he makes a living selling photographic studies artists,'Documents pour Artistes'.

1895 Moves to Montparnasse where he will live for the rest of his life.

1897 Begins systematically to photograph Paris.

1901 Clientele includes visual artists, craftsmen, 'connoisseurs of O Paris', libraries and institutions, such as the Bibliothèque Historiqu de la Ville de Paris, Bibliothèque Nationale, École des Beaux Art Musée Carnavalet and the Victoria and Albert Museum, London.

1907 Undertakes largest commission of his career – systematic topograph

survey of several *quartiers* of central Paris for Bibliothèque Historique de la Ville de Paris.

1910 Begins series of albums on specific themes for Bibliothèque Nationale, such as 'Parisian Interiors', 'Vehicles of Paris','Boutiques of Old Paris' and 'Rag-pickers'.

12–1918 Business begins to dwindle after part of commission to photograph the Tuileries Gardens is rejected by Bibliothèque Historique de la Ville de Paris. During World War I, he almost ceases taking pictures.

1919 After the war, begins to photograph again.

1920 Sells 2,621 glass-plate negatives to Service Photographique des Monuments Historiques for 10,000 francs. Starts to photograph in the countryside around Paris, especially at Saint-Cloud.

25–1926 Photographs cafes and theatres of Paris and the Parc de Sceaux. His work attracts the attention of the Surrealists, particularly his neighbour, Man Ray.

1926 *L'Eclipse*, is used as the cover of the magazine *La Révolution Surréaliste*. Devastated by the death of his companion, Valentine.

1927 4 August, dies and is buried in municipal cemetery at Bagneux, south of Paris. Three months later, his photographs are exhibited for the first time in Premier Salon Indépendent de la Photographie. Contents of his studio left in care of old friend, André Calmettes, who sells or gives 2,000 negatives to the Monuments Historiques, Paris.

1928 Negatives and prints sold to Berenice Abbott and Julien Levy.

1929 Work included in the influential exhibition 'Film und Foto', Stuttgart.

1930 First monograph on Atget, *Atget: Photographe de Paris* is published.

1969 Museum of Modern Art, New York, acquires Abbott-Levy collection of Atget prints and negatives.

Photography is the visual medium of the modern world. As a means of recording, and as an art form in its own right, it pervades our lives and shapes our perceptions.

55 is a new series of beautifully produced, pocket-sized books that acknowledge and celebrate all styles and all aspects of photography.

Just as Penguin books found a new market for fiction in the 1930s, so, at the start of a new century, Phaidon 55s, accessible to everyone, will reach a new, visually aware contemporary audience. Each volume of 128 pages focuses on the life's work of an individual master and contains an informative introduction and 55 key works accompanied by extended captions.

As part of an ongoing program, each 55 offers a story of modern life.

Eugène Atget (1857–1927) took over 10,000 photographs of the trades, shops, architecture and street scenes of Paris and its surrounding area. Intended only as records for libraries and museums, Atget modestly called his images 'documents for artists'. Yet since his death his reputation has grown into that of one of the world's pre-eminent photographic artists.

Gerry Badger is a photographer, architect and curator. His books include monographs on Atget and Paul Graham. He currently teaches history of photography at Brighton University.

Phaidon Press Limited
Regent's Wharf
All Saints Street
London N1 9PA

Phaidon Press Inc.
180 Varick Street
New York NY 10014

www.phaidon.com

First published 2001
©2001 Phaidon Press Limited

ISBN 0 7148 4049 1

Designed by Julia Hasting
Printed in Hong Kong

Photographs reproduced by permission of: CMN, Paris; Photothèque des Musées de la ville de Paris; The Gilman Paper Company Collection, New York.